The Faeries of Waterlily Woods

www.colouringandtangling.com

Legal

Copyright © 2016 Lesley Smitheringale

This publication is protected by copyright law. Please respect the law. No part of this publication may be reproduced, reused, republished, or distributed in any form or by any means, electronic or mechanical, or stored in a database or retrieval system. The colourings in this book are for personal use only and you are permitted to photocopy or scan the original pages for your own personal use in order to try out different colour palettes and media.

The blank, uncoloured templates in this book may not be posted on websites, blogs or social media such as Pinterest, Instagram or Facebook Pages and Groups without prior, written permission from the artist, Lesley Smitheringale.

You may, however, post your works in progress and completed colourings from this book. This would be greatly appreciated but please mention that they are from the book "The Faeries of Waterlily Woods" by Lesley Smitheringale from Colouring and Tangling.

Aknowledgements

I would like to thank my gorgeous Team of colourists who creatively colour and test out the illustrations before publication. The book would not be possible without you and thank you also for your wonderful support of me as an artist and for your colouring talent which continues to amaze me. You are truly inspirational to the colouring world. xxx

Credits

Front Cover "Rebella's Farewell" coloured by Tina Maheras

Back Cover
"Aqualina on her way to Morning Tea" coloured by Tina Maheras
"The Leaf Goblin and Woodland Friends" coloured by Wendy Russell
"Playing with Dragonflies" - Dragonfliella coloured by Tina Maheras
"Rosa on Lotus Flower" coloured by Donna Pecoraro

www.colouringandtangling.com

About the Artist

Lesley lives and works in her home studio in the Redlands area of Queensland, Australia. She was born in Glasgow, Scotland where she obtained a BA with Honours in Design at Glasgow School of Art. She then did further training to become an art teacher and after teaching for twenty years to Middle and High School students, Lesley took the plunge and decided to work for herself. She currently teaches extra-curricular art to children, produces her own artwork, hand-made gifts, illustrates and self-publishes art & craft books.

Keep up-to-date

If you love to colour and tangle, Lesley also runs a website and online Shop at Colouring and Tangling where she offers inspiration, tips & techniques, video instruction and a large range of products such as books, printable pdfs, Calendars, Cards, Bookmarks, Artist Prints and Giftware for colourists and lovers of zentangle-inspired art. She also hosts a Colouring and Tangling Group on Facebook which anyone can join, offering you the opportunity to showcase your work and meet a creative, virtual community.

http://www.colouringandtangling.com
https://www.facebook.com/groups/colouringandtangling/
https://www.etsy.com/shop/ColouringandTangling

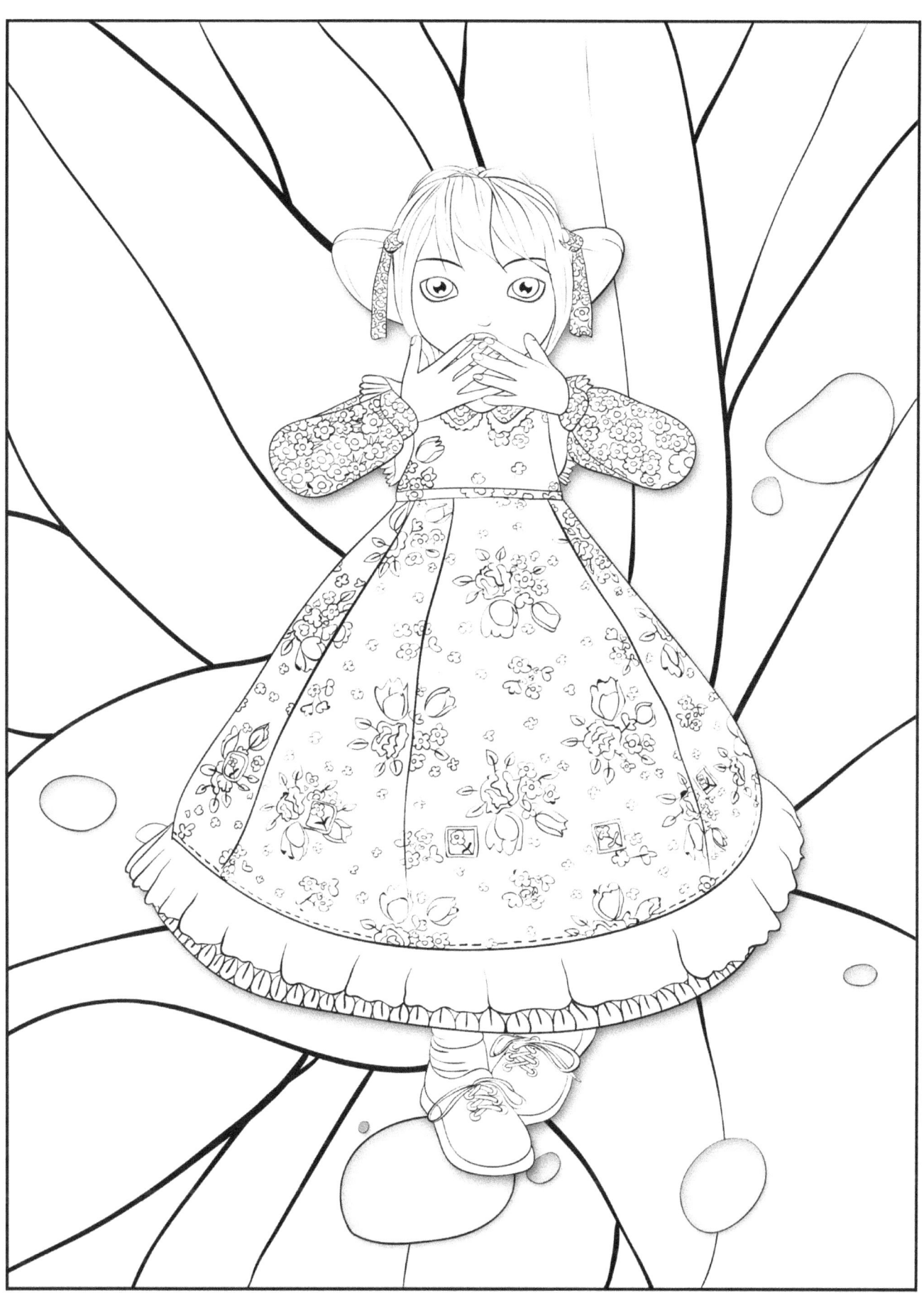

"Rosa on Lotus Flower"

Early one morning with rain drops on the flowers and lily pads, Rosa, a little mouse creature is standing in the centre of a lotus flower at Waterlily Woods. She sees something in the Woodlands which shocks her. She does not know what to do or if she should tell anyone.

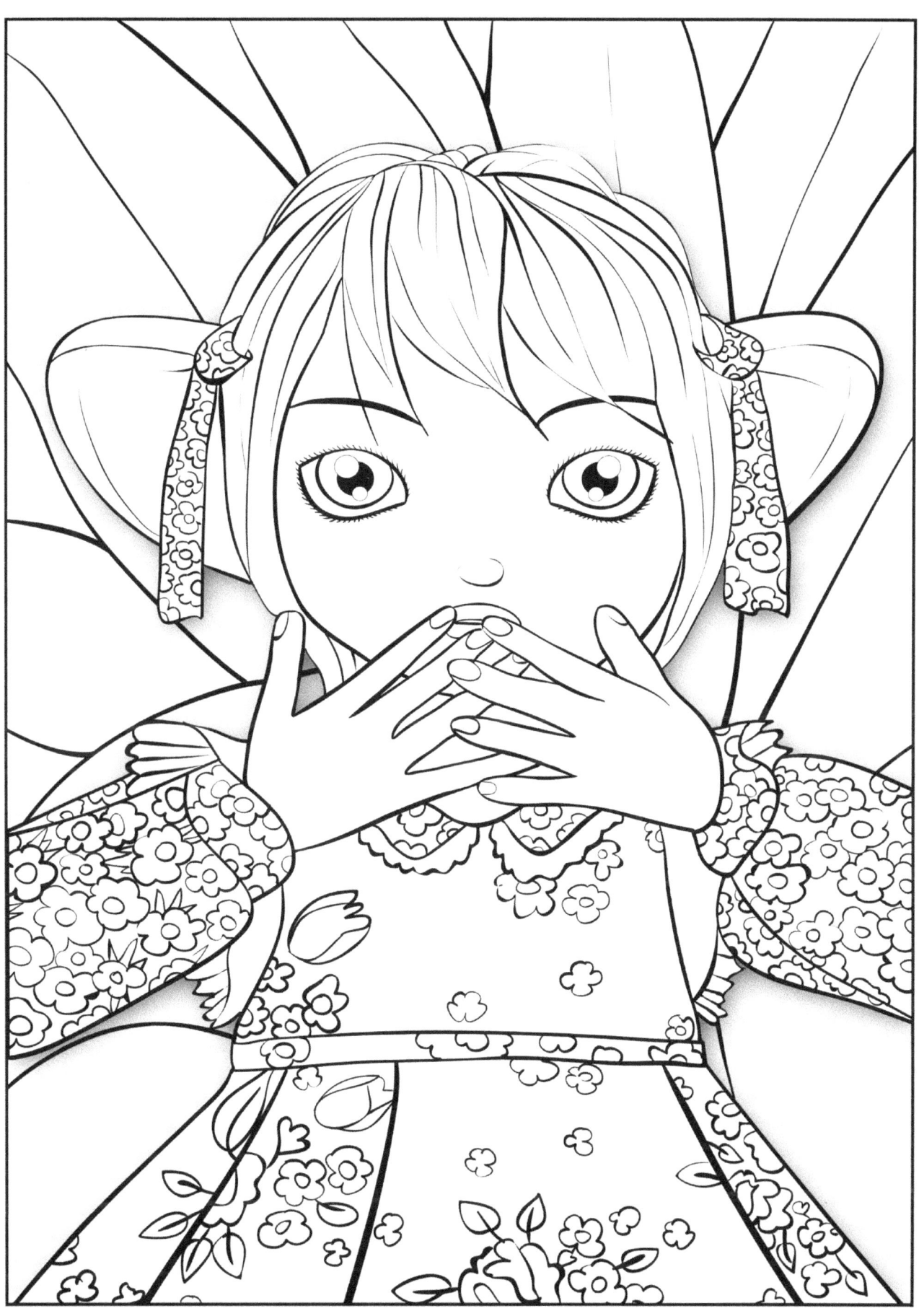

"Rosa's Surprise"

Early one morning with rain drops on the flowers and lily pads, Rosa, a little mouse creature is standing in the centre of a lotus flower at Waterlily Woods. She sees something in the Woodlands which shocks her. She does not know what to do or if she should tell anyone.

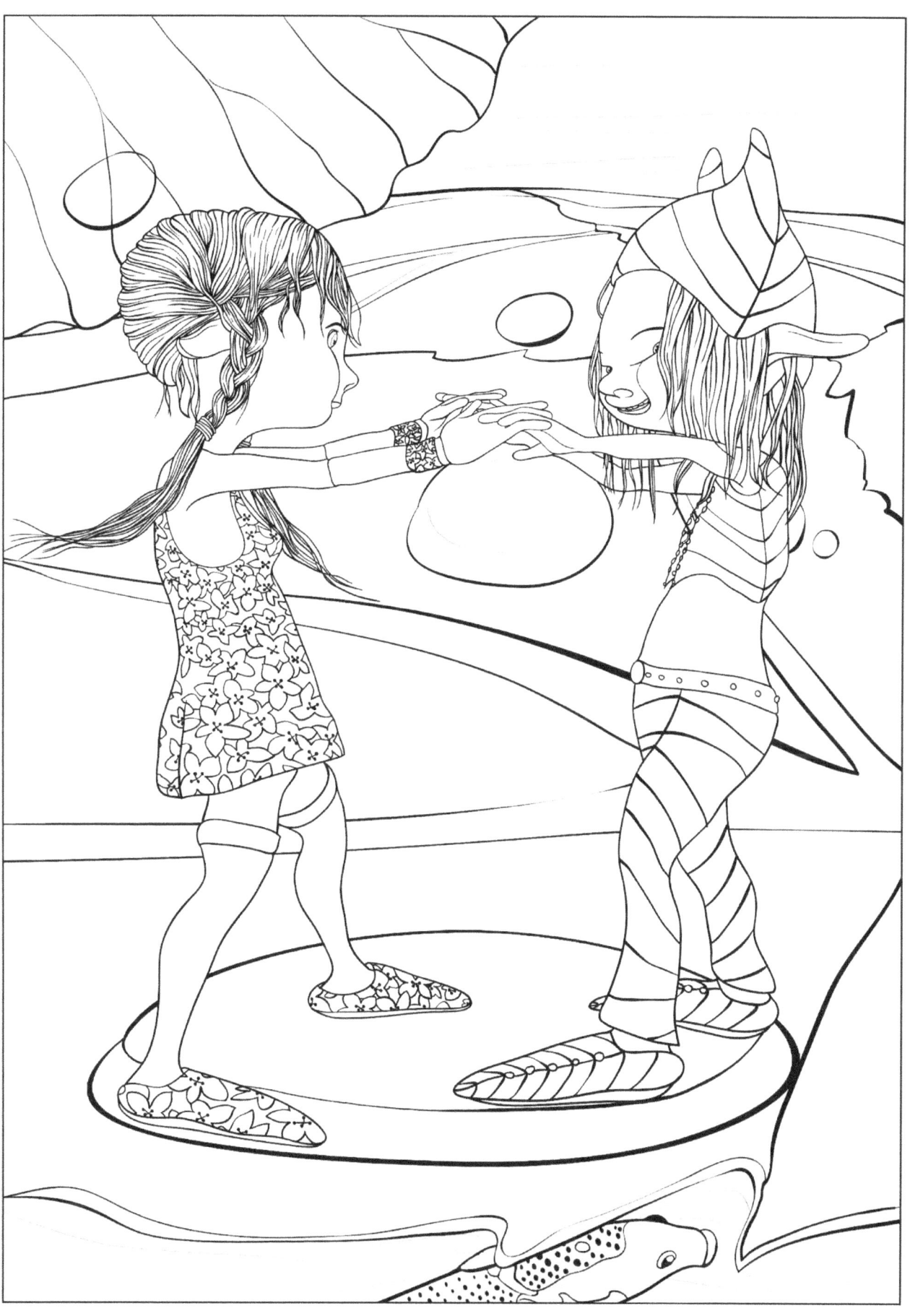

"Raindance" Rebella & the Leaf Goblin

This is what Rosa witnesses that morning. Rebella, who belongs to Rosa's Faerie Ring, is having a romance with a Leaf Goblin from another Faerie Ring which is forbidden. Rebella and the Leaf Goblin are dancing after an early morning rain shower, standing on a raindrop and playing with one as they hold hands, in love, on the lily pads. They have no idea that someone is watching them...

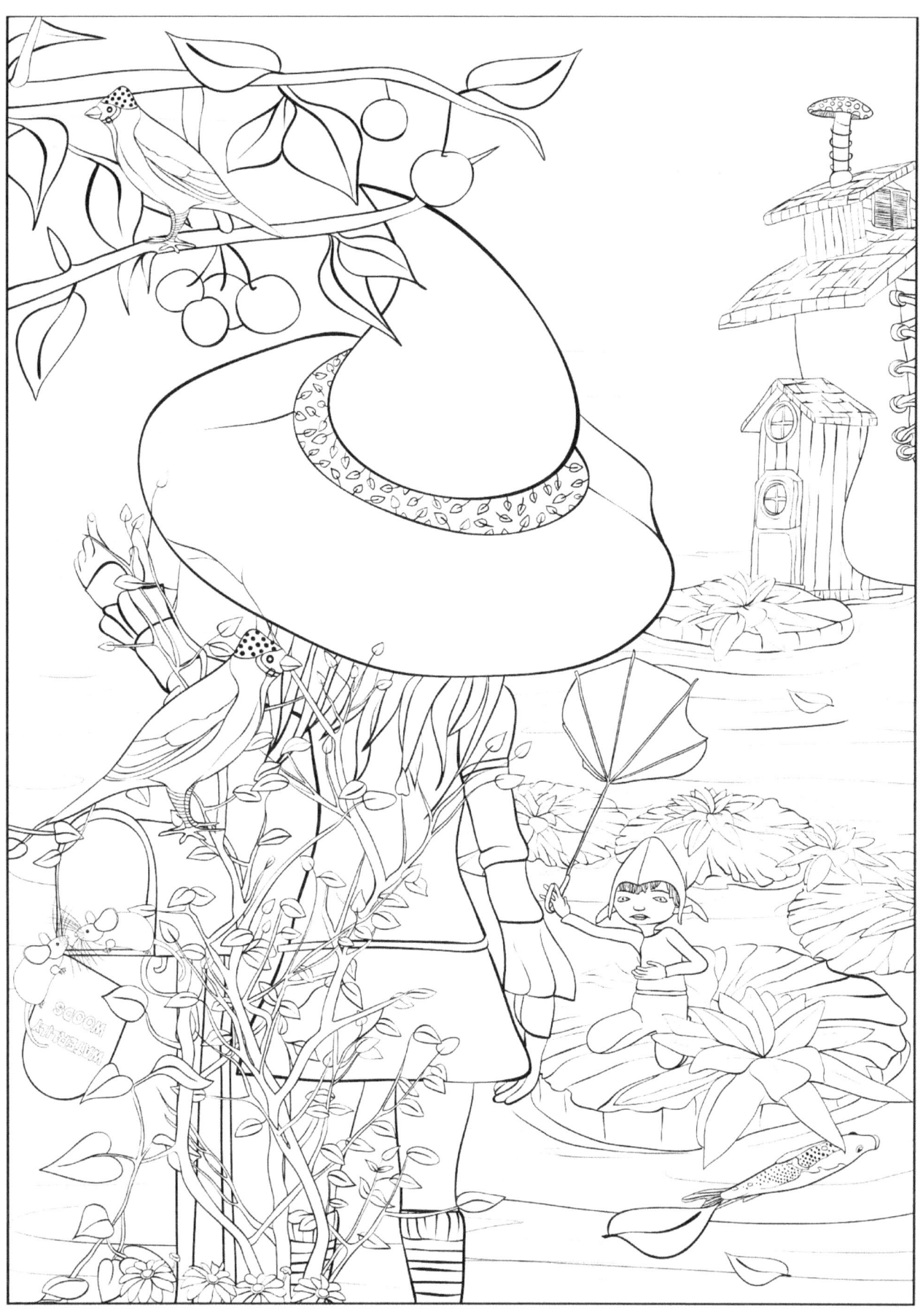

"Rebella's Farewell"

Due to seeing a Leaf Goblin, Rebella has been banished from her Faerie Ring. Before she leaves, she looks over her home at Waterlily Woods as a storm brews with a cold wind blowing the leaves around the lake. She waves goodbye to the sad little pixie holding an upturned leaf umbrella. He is secretly in love with Rebella and his heart is broken because she is leaving....

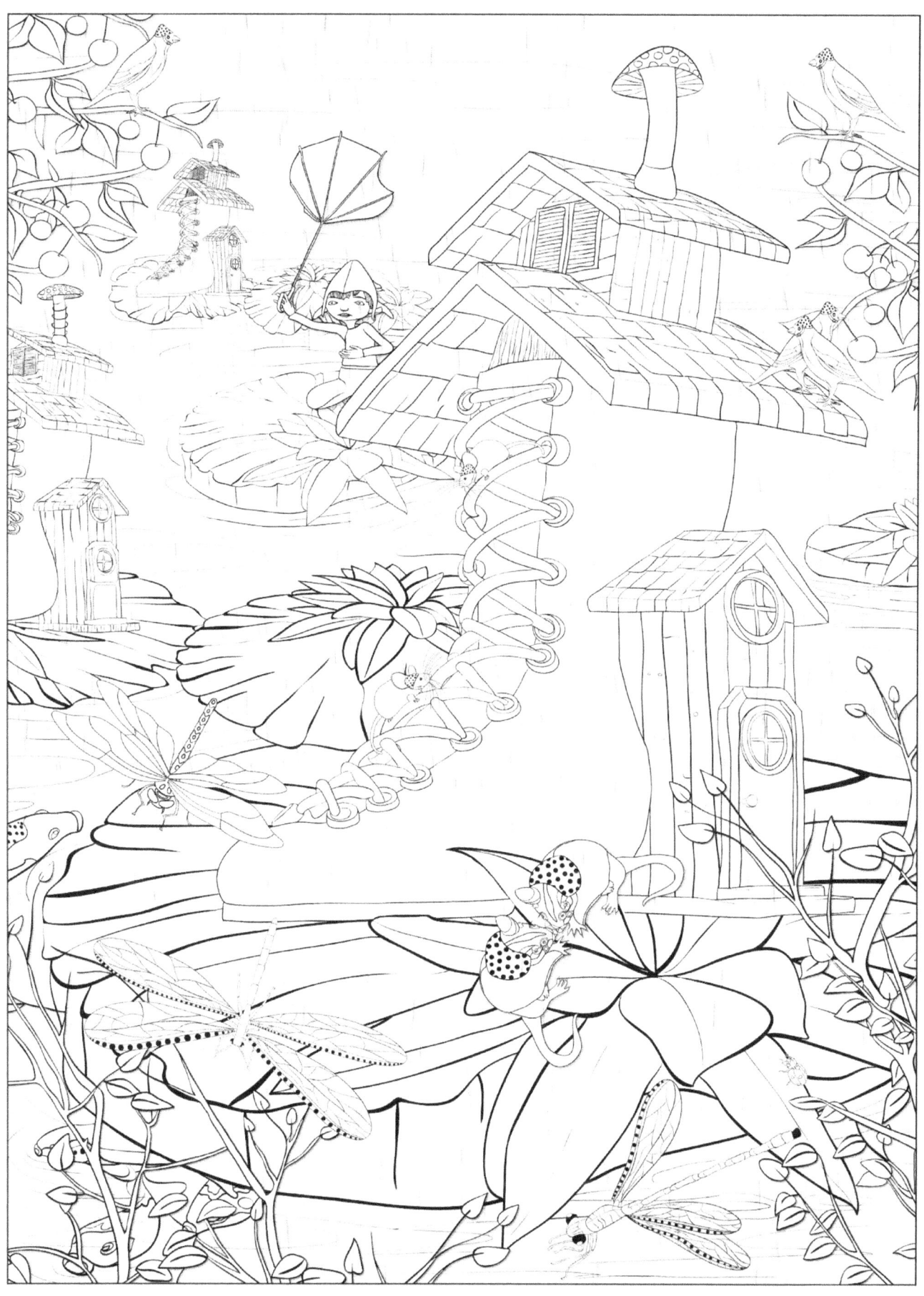

"Rainstorm at Waterlily Woods"

In the early evening after Rebella has left, the storm worsens at Waterlily Woods. Heavy rain pelts down on the lake with the faeries safely inside their homes. All of the animals and birds are trying to find shelter, wearing their toadstool hats for protection. The only faerie braving the elements is the sad pixie who waits in hope that Rebella will return...

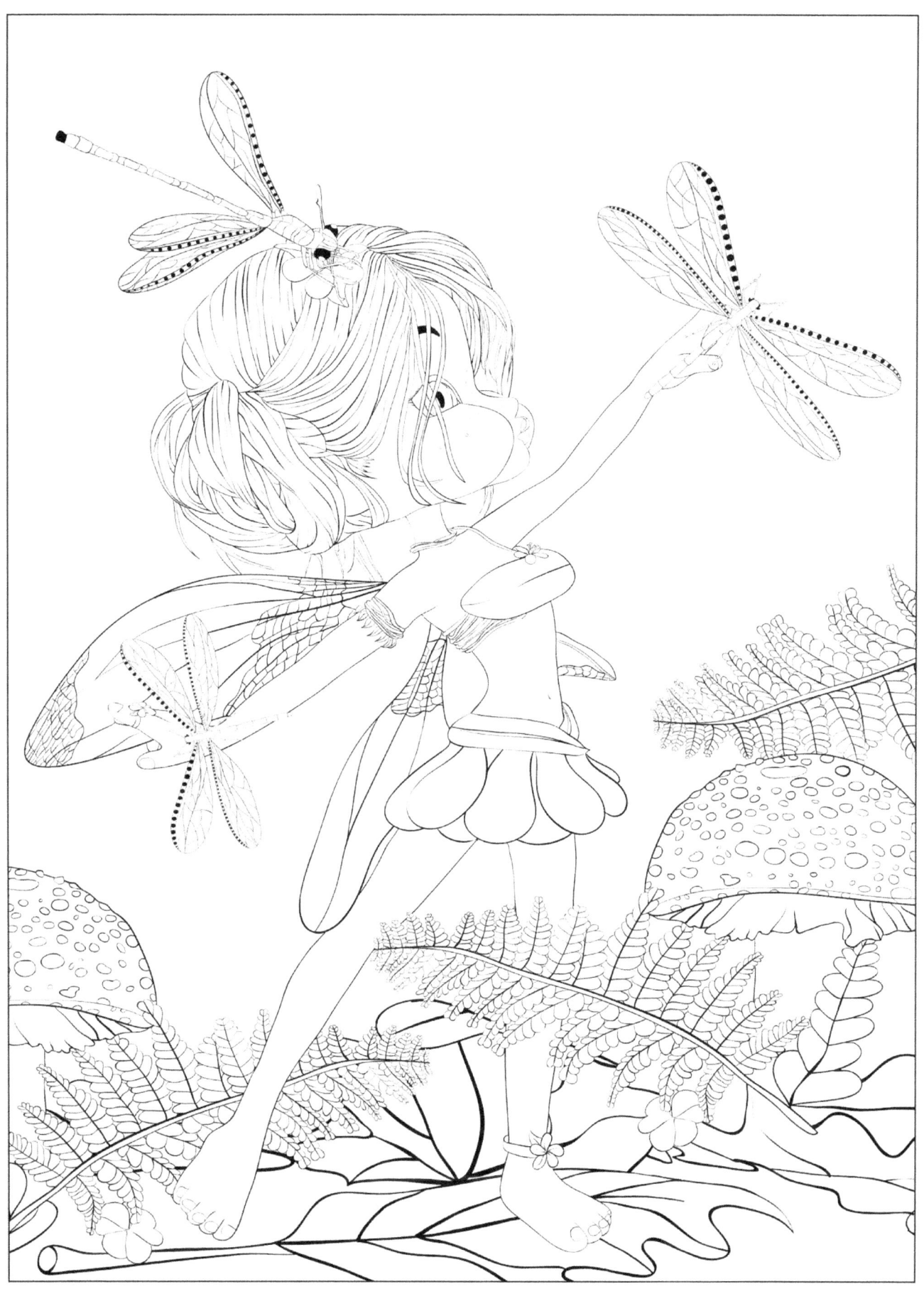

"Playing with Dragonflies" - Dragonfliella

Little Dragonfliella has dragonfly wings and her clothes are made from a lotus flower. She loves to fly and play with the dragonflies of Waterlily Woods. Dragonfliella also glows and her soft light can be seen in the early evenings when she darts around the lake with her dragonfly friends...

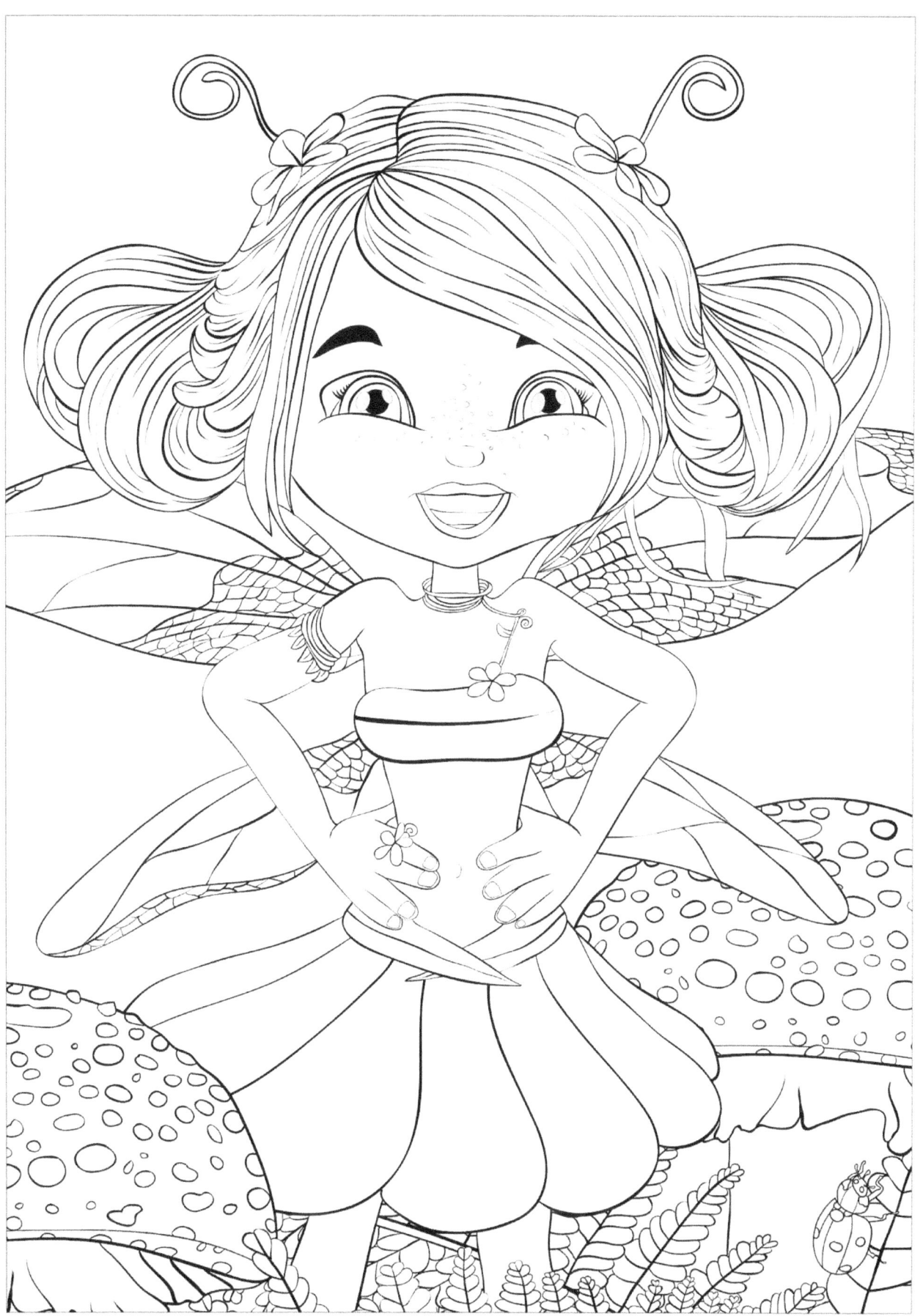

"Dragonfliella"

Little Dragonfliella has dragonfly wings and her clothes are made from a lotus flower. She loves to fly and play with the dragonflies of Waterlily Woods. Dragonfliella also glows and her soft light can be seen in the early evenings when she darts around the lake with her dragonfly friends...

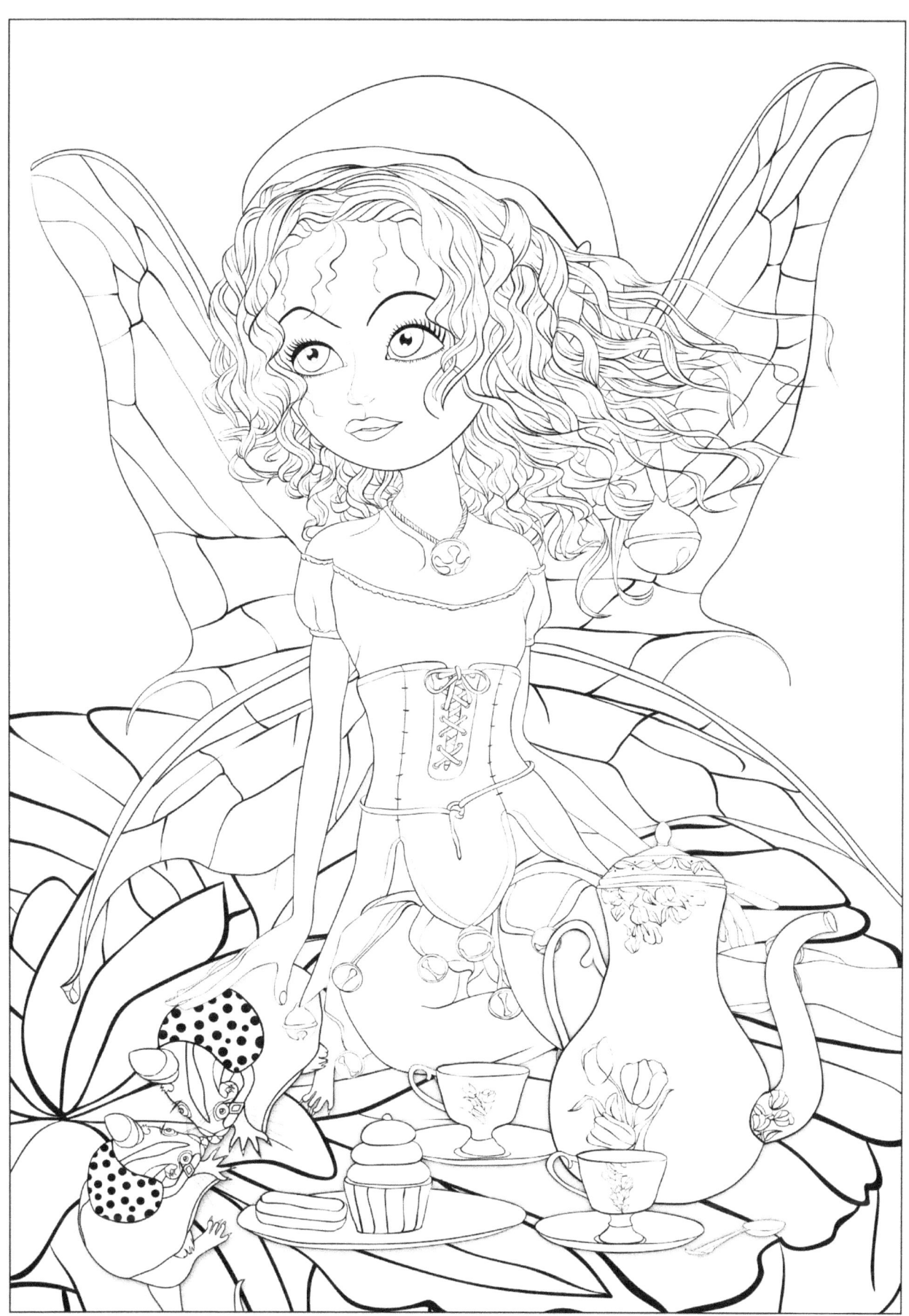

"Tealani having Afternoon Tea"

The beautiful Tealani loves to drink tea with sweet treats every day on the lily pads. A pair of sugar gliders wearing toadstool hats join her for afternoon tea. She has the most delicate, iridescent wings and wears a bodice, hat and necklace with jingle bells. When Tealani is not having tea, she can be heard by her soft tinkle as she flies around Waterlily Woods...

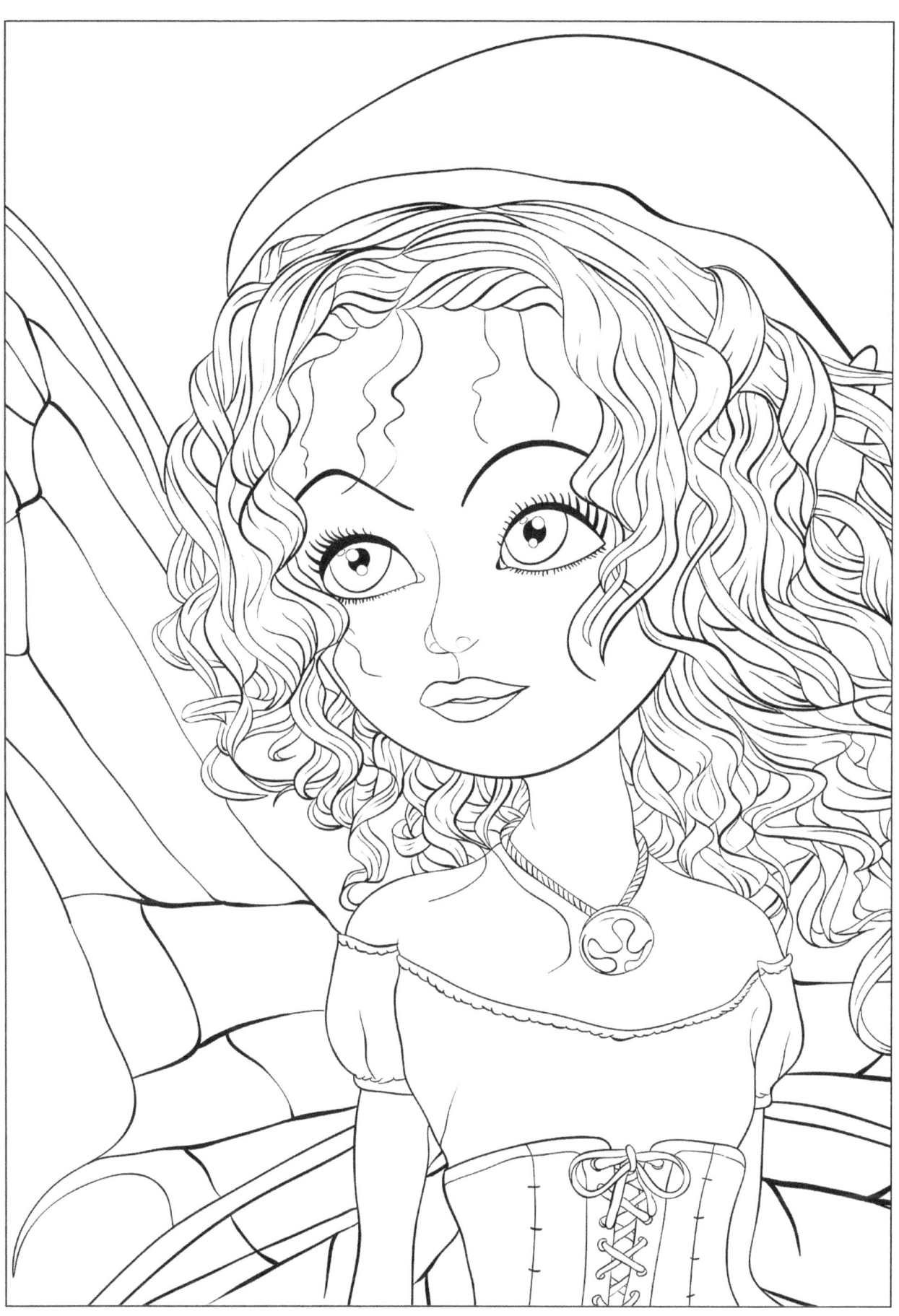

"Tealani"

The beautiful Tealani loves to drink tea with sweet treats every day on the lily pads. A pair of sugar gliders wearing toadstool hats join her for afternoon tea. She has the most delicate, iridescent wings and wears a bodice, hat and necklace with jingle bells. When Tealani is not having tea, she can be heard by her soft tinkle as she flies around Waterlily Woods...

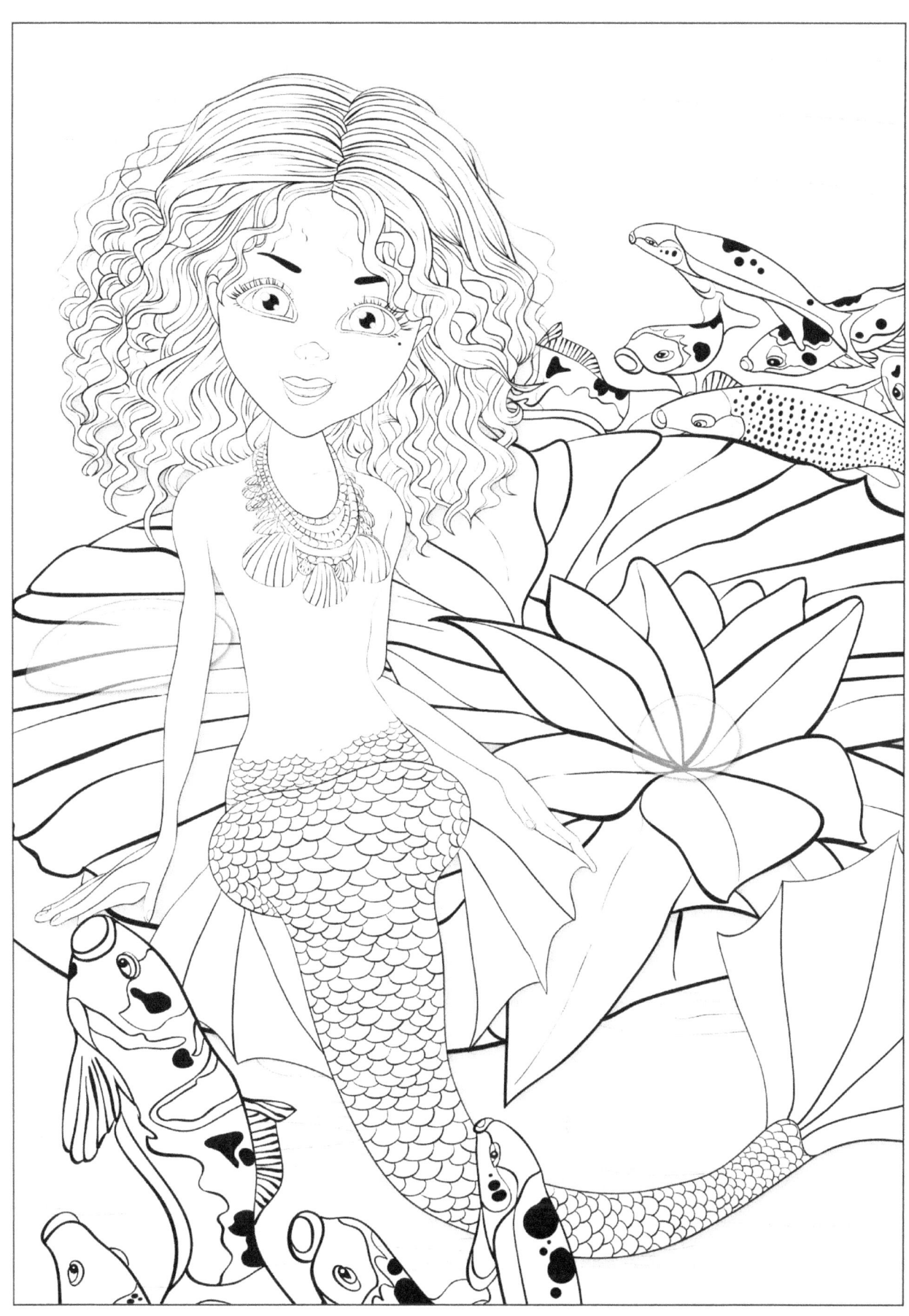

"Aqualina and her Koi friends"

Aqualina, a beautiful mermaid who swims with the koi fish in the lake at Waterlily Woods is Tealani's best friend. Aqualina wears a necklace made of pearls and seashells and has the most stunning tail which shimmers as she glides through the water. The koi fish love her and follow her everywhere she goes...

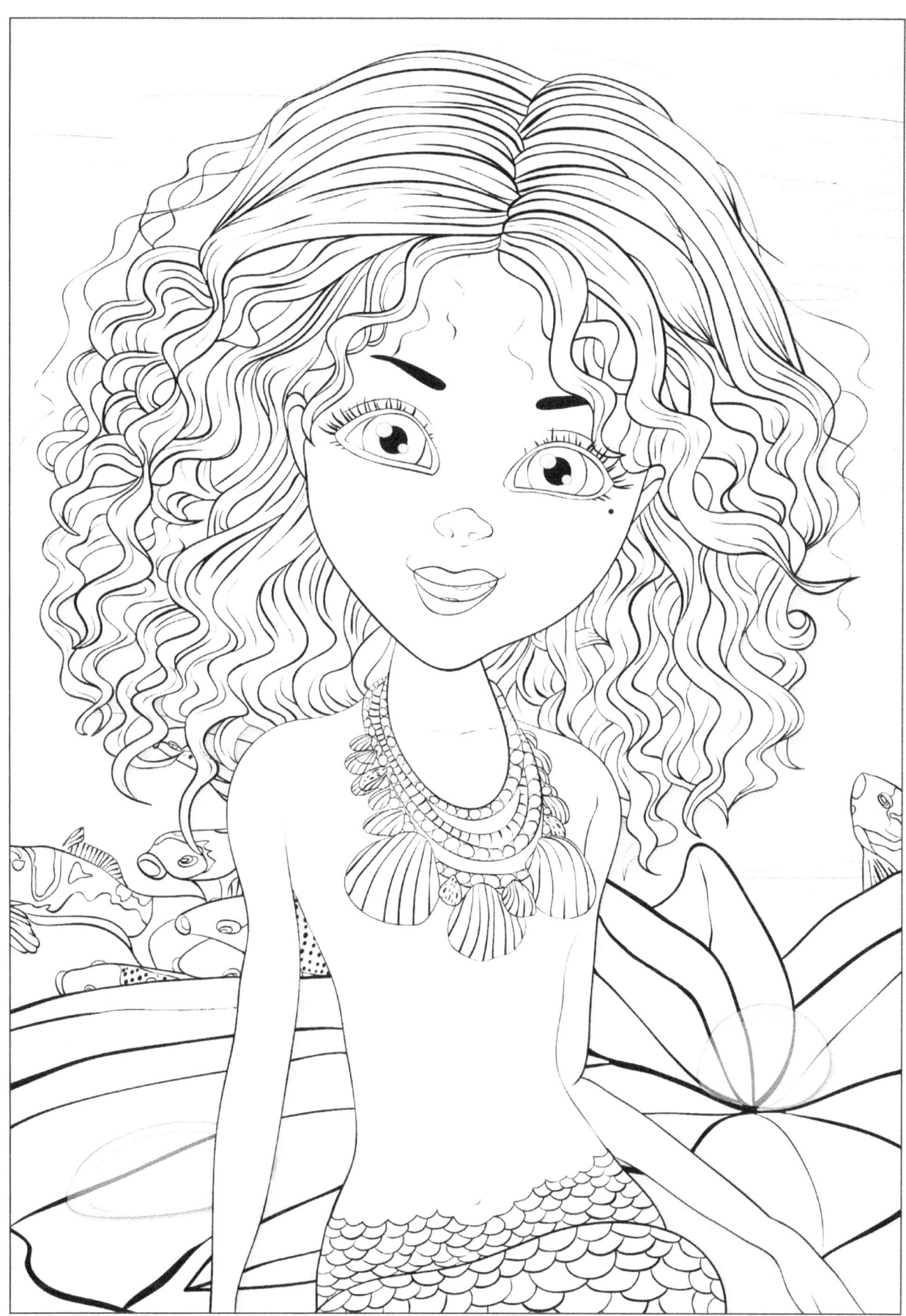

"Aqualina"

Aqualina, a beautiful mermaid who swims with the koi fish in the lake at Waterlily Woods is Ceelani's best friend. Aqualina wears a necklace made of pearls and seashells and has the most stunning tail which shimmers as she glides through the water. The koi fish love her and follow her everywhere she goes...

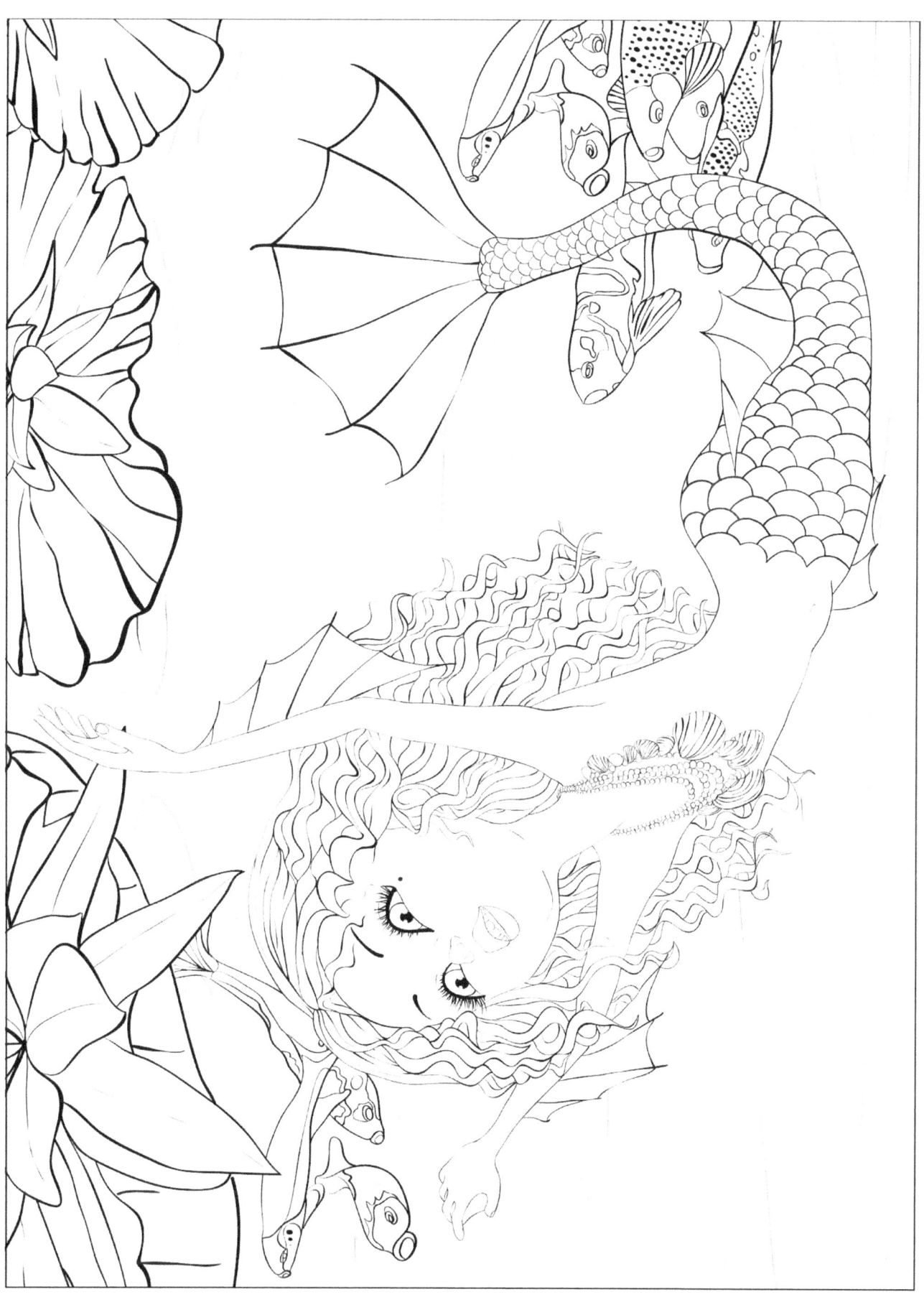

"Aqualina on her way to Morning Tea"

Aqualina, a beautiful mermaid who swims with the koi fish in the lake at Waterlily Woods is Tealani's best friend. She is on her way to join Tealani for Afternoon Tea, closely followed by the koi fish who love her...

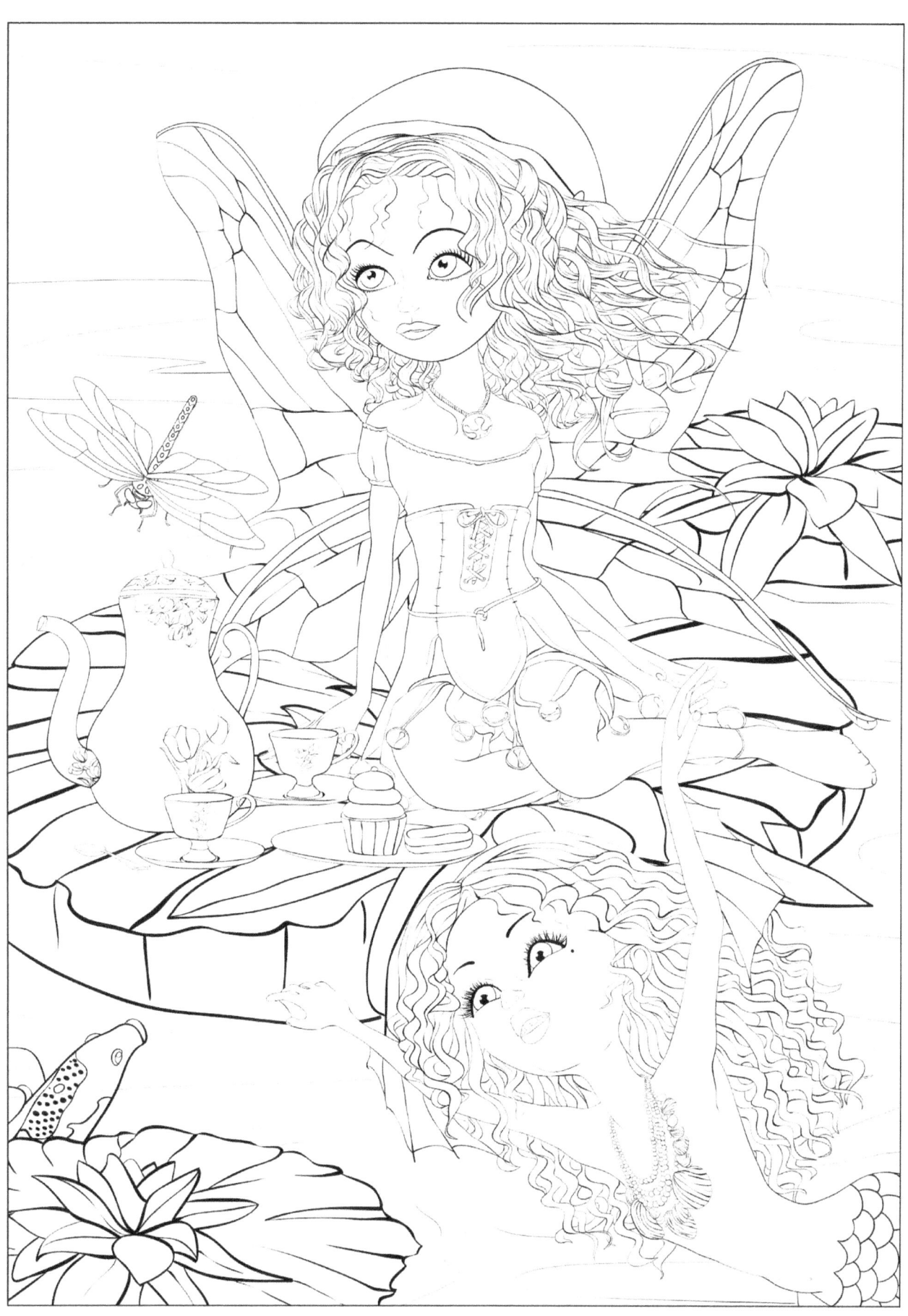

"Tealani and Aqualina having Afternoon Tea"

Aqualina is Tealani's best friend and every day she swims over to meet Tealani on her lily pad and has tea and sweet treats with her. They drink out of the finest china tea set...

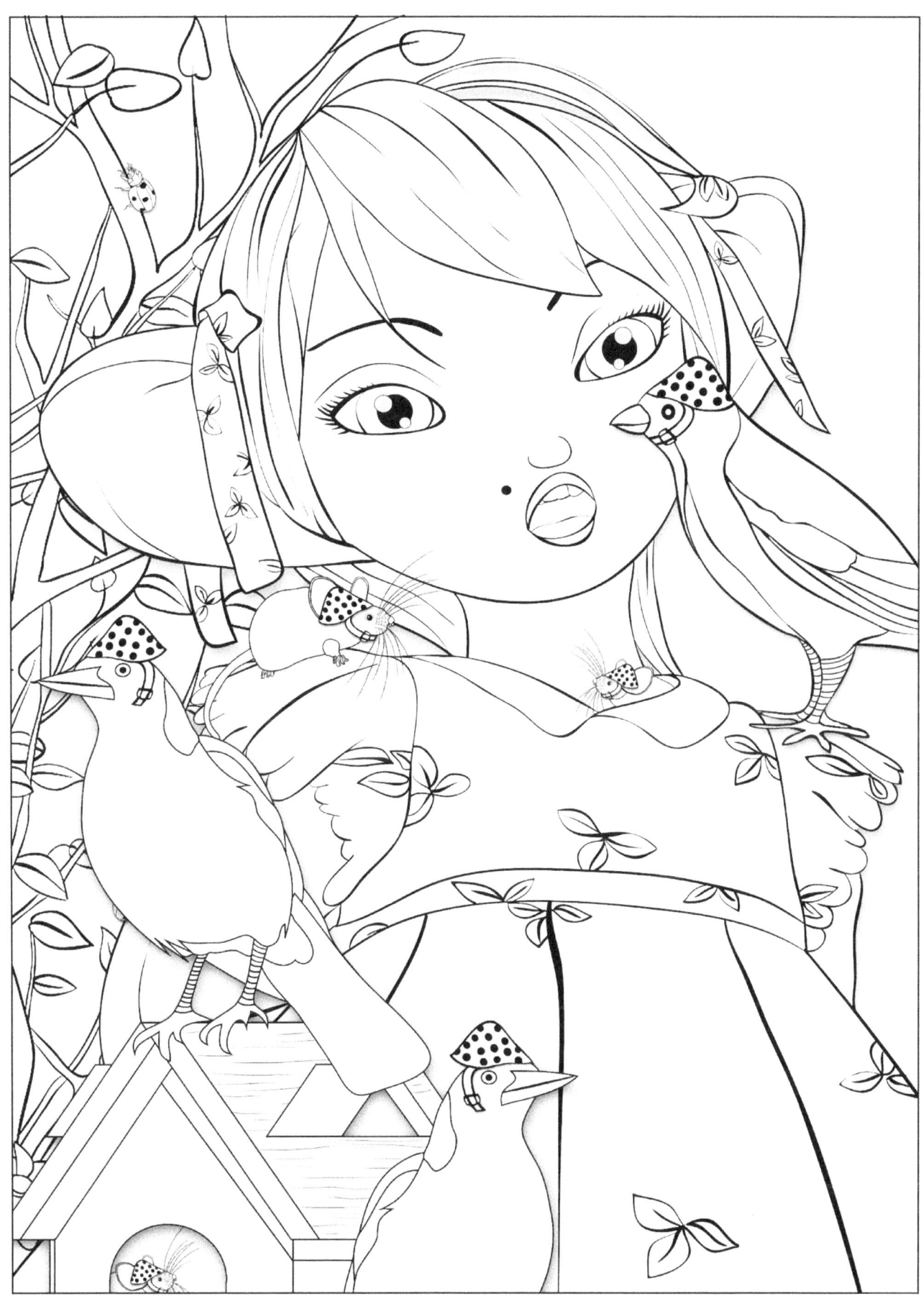

"Vanella and her Woodland Friends"

Vanella is a mouse creature and the twin sister of Rosa. They are identical apart from Vanella having a little beauty mark. Vanella is an animal lover and makes toadstool hats for the birds and animals in Waterlily Woods to protect them in rainstorms...

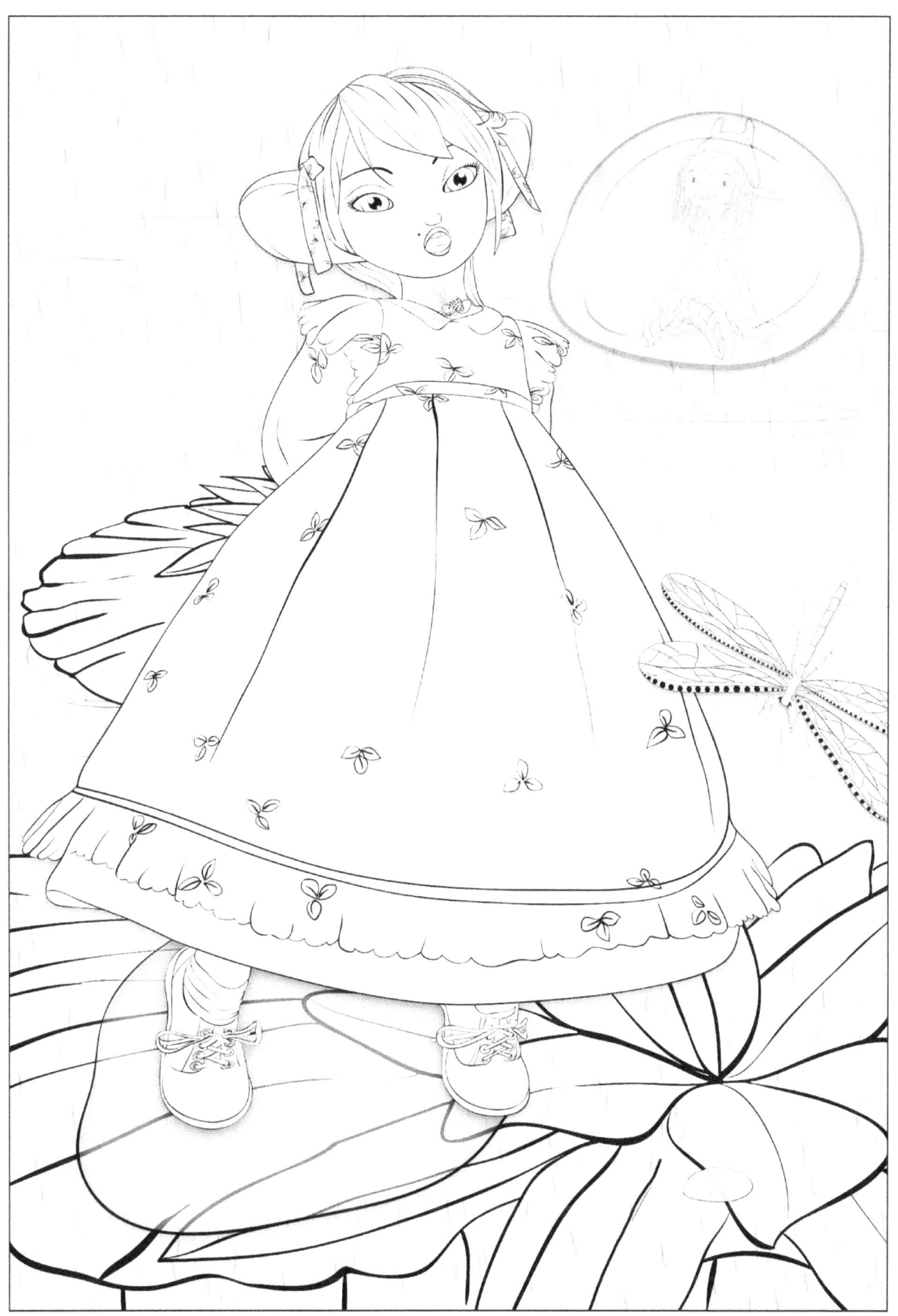

"Vanella and the Rain Goblin"

Vanella, the protector of wildlife in Waterlily Woods, is visited by a Rain Goblin during an afternoon shower. The Goblins are harmless but mischievous and squeeze themselves into raindrops ...

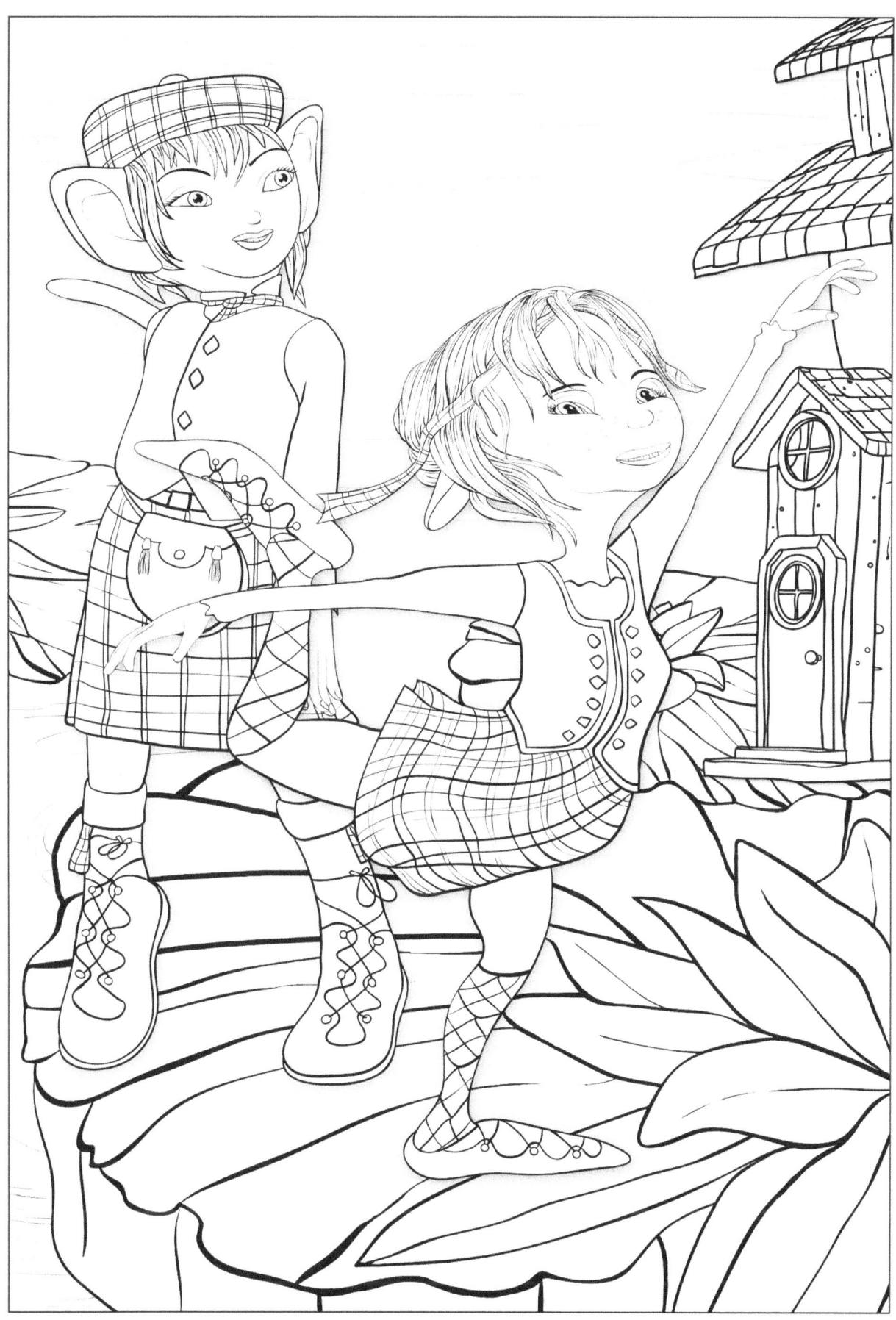

"Keltan and Keltani"

These Scottish faeries are distant cousins of Rebella and are visiting Waterlily Woods after hearing about Rebella being banished from the Faerie Ring. They have come all the way from the Highlands of Scotland and are dressed in the traditional attire of tartan kilts, socks and laced up dancing shoes...

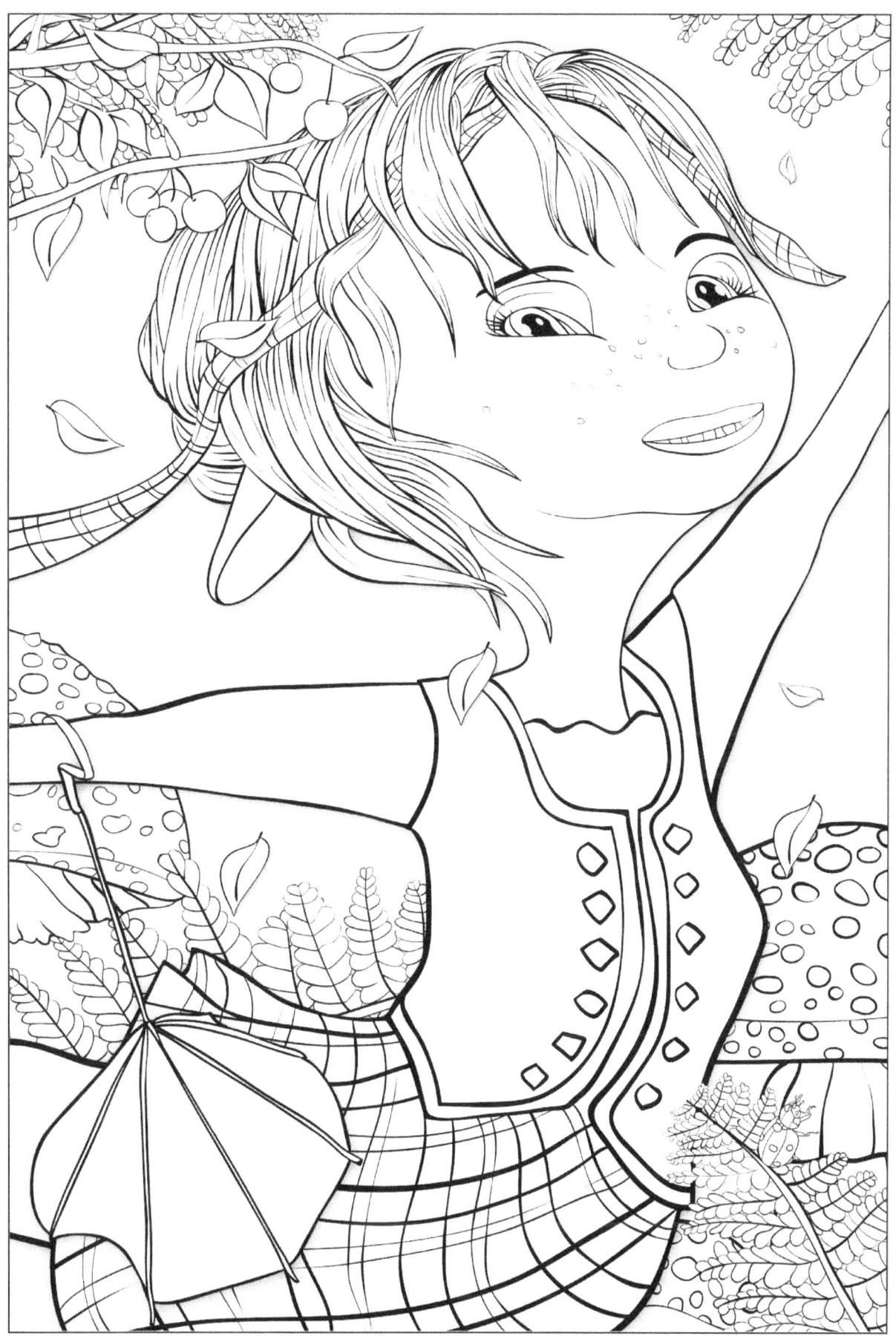

"Keltani in Autumn Leaves"

Keltani is a Scottish faerie, dancer and distant cousin of Rebella. She has travelled all the way from the Highlands of Scotland with her brother to help Rebella who has been banished from her Faerie Ring. She saw the swirling leaves in Waterlily Woods and decided to dance with them...

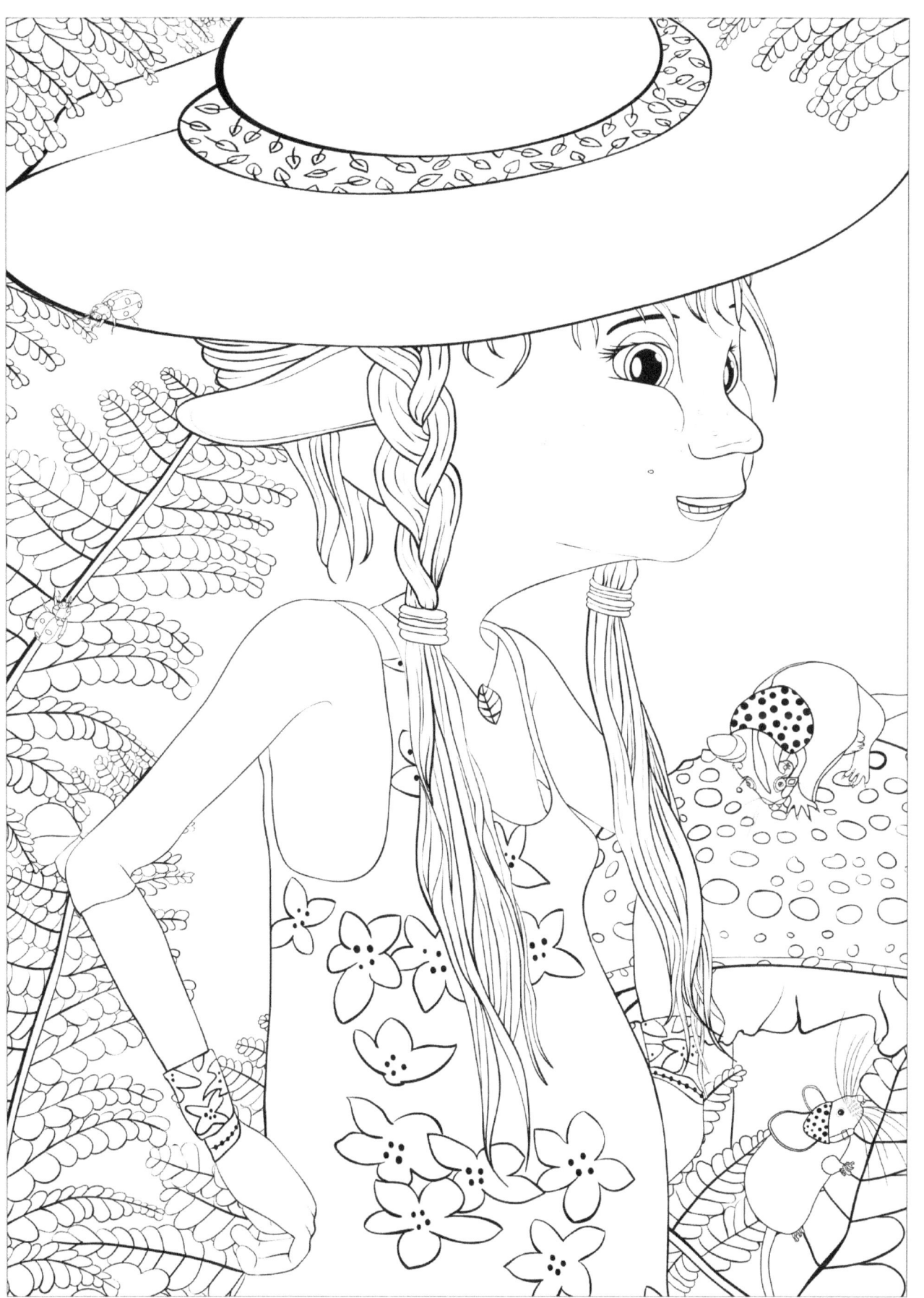

"Rebella in the Woods"

A few weeks after being banished from her Faerie Ring, Rebella is reflecting in the Woods, wondering why her Leaf Goblin spends more and more time with his goblin friends and is nowhere to be seen....

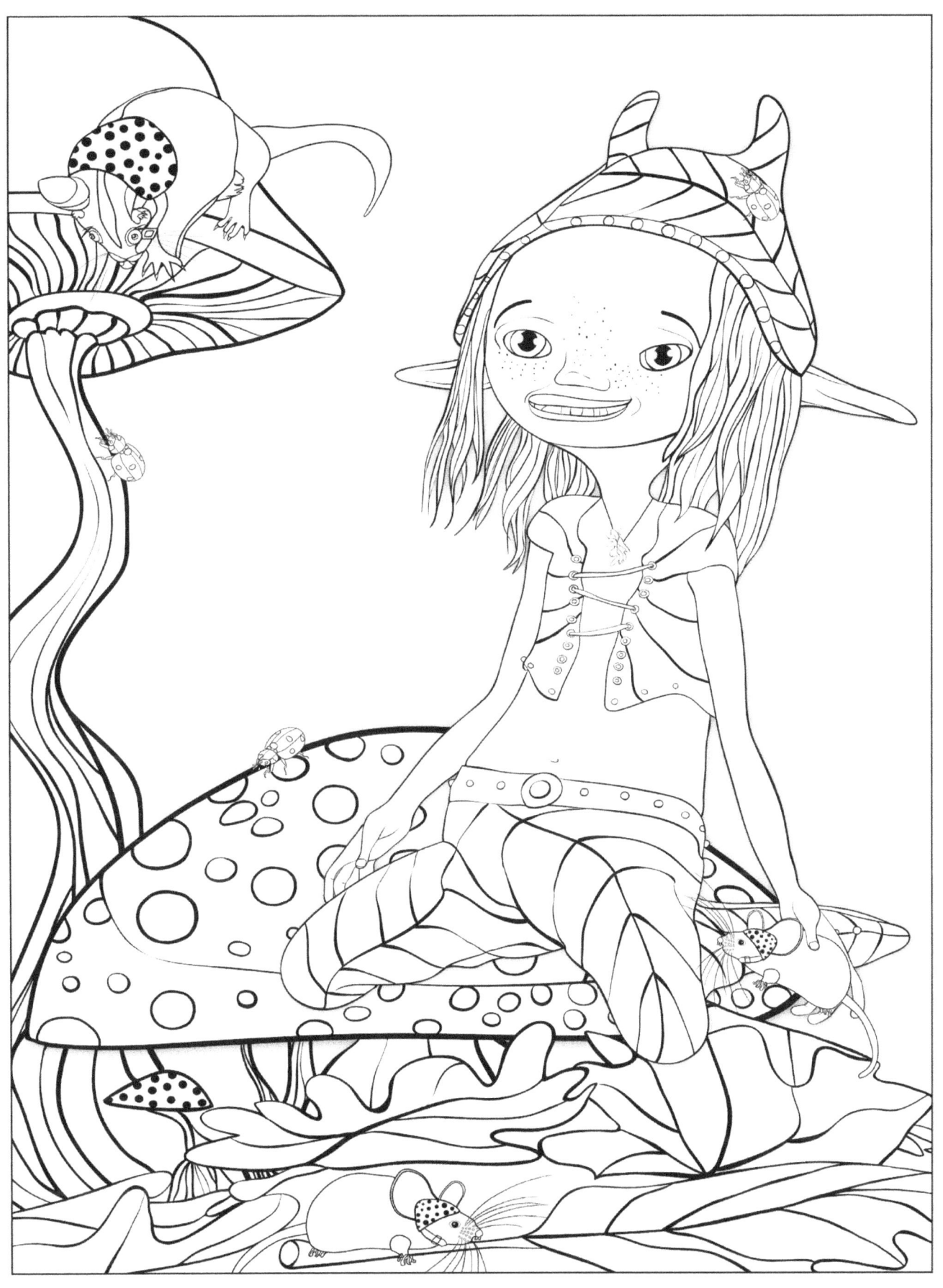

"The Leaf Goblin and Woodland Friends"

The Leaf Goblin wears a hat, shoes and clothing made from leaves. He and his fellow Goblins live in the Woodlands surrounding the faeries who live on the waterlilies in the nearby lake. He loves to fly on leaves with his Goblin friends on windy days....

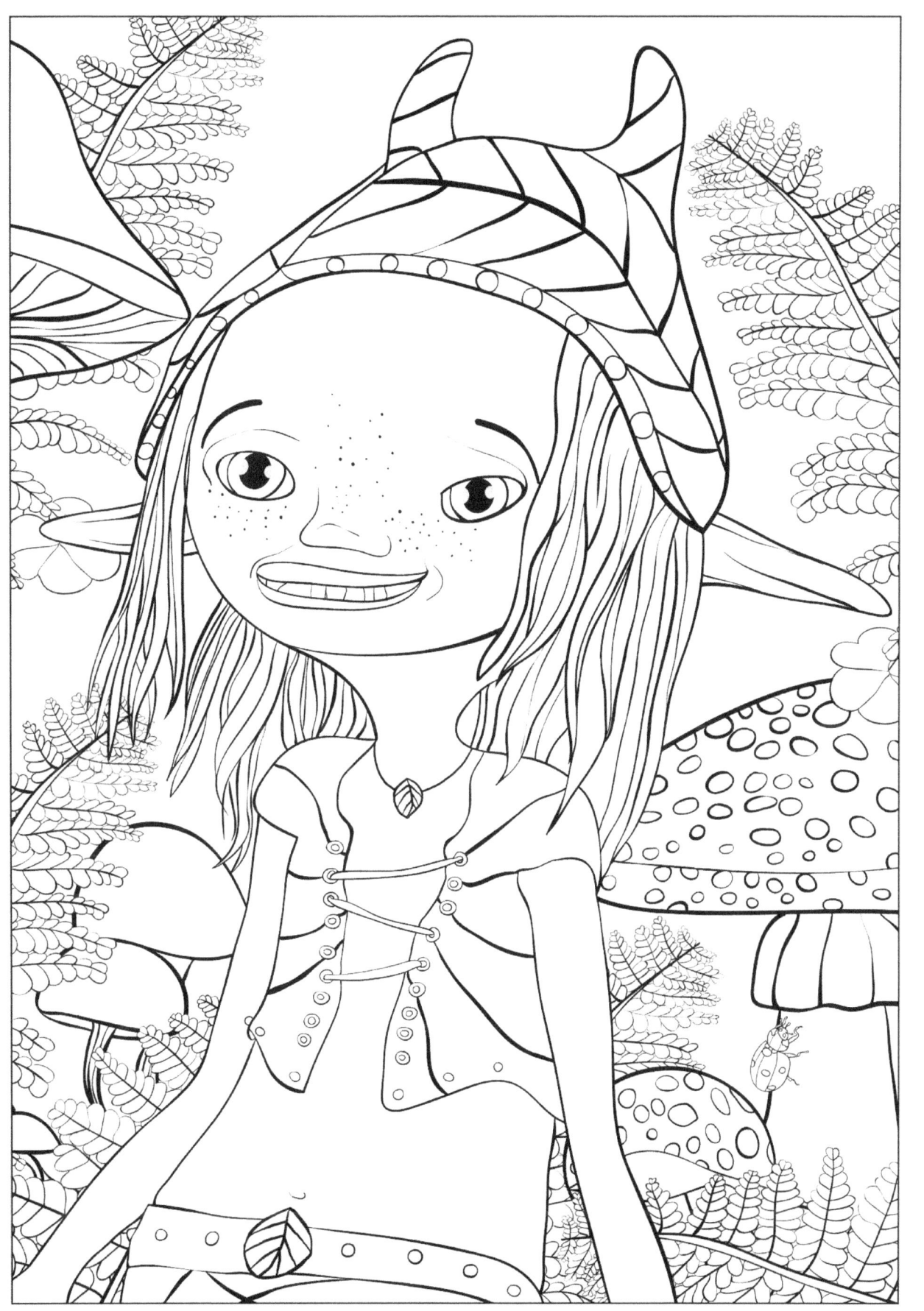

"The Leaf Goblin in the Woods"

The Leaf Goblin is a cheeky little fellow who has won Rebella's heart. Their romance is forbidden as they are from different faerie rings. He loves to spend time playing with his fellow Goblins and getting up to mischief

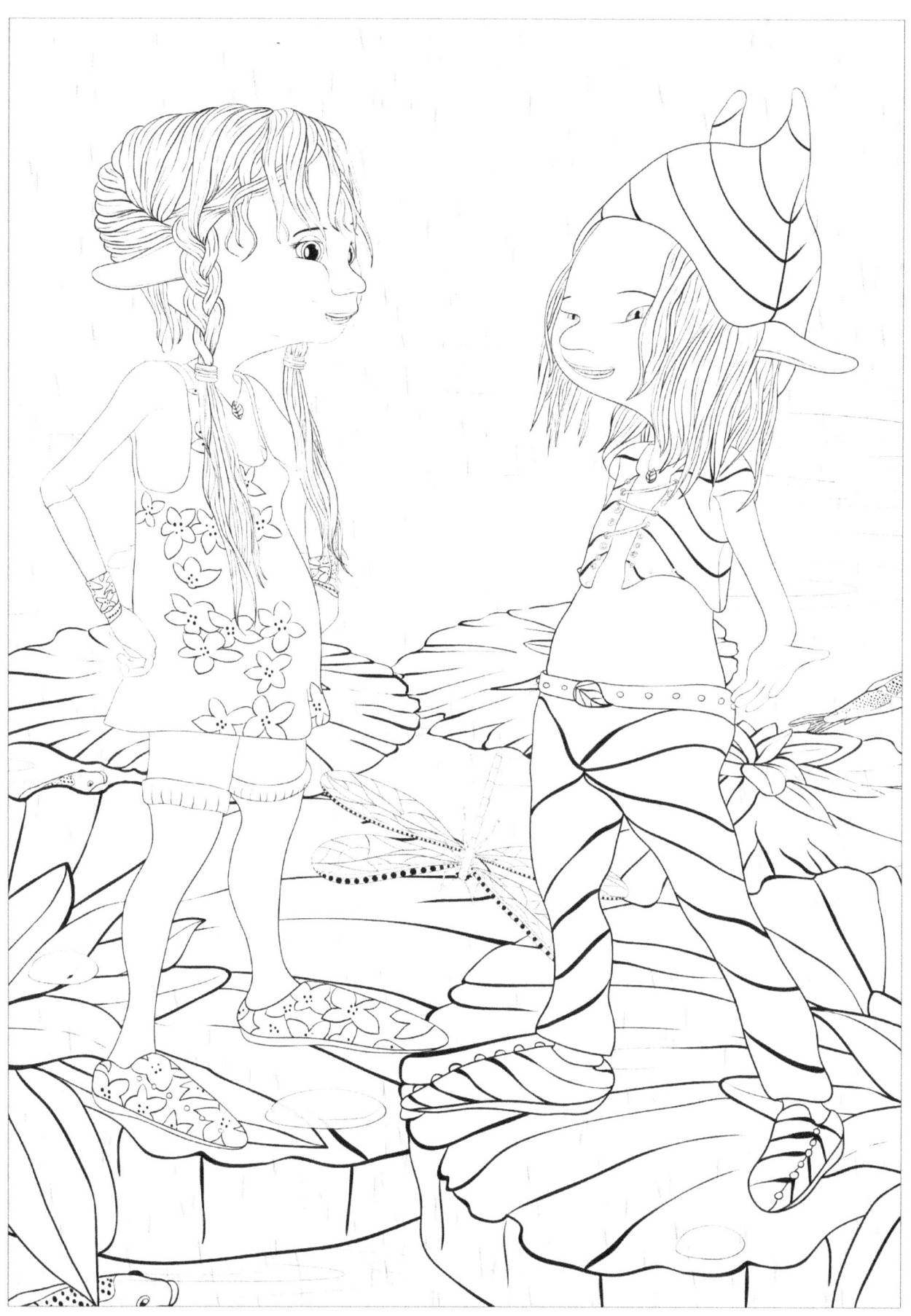

"The Quarrel"

Rebella confronts the Leaf Goblin about why he is spending so much time away from her to be with his friends. He gave her a leaf necklace and promised he would love her forever. In the pouring rain the two faeries have a huge quarrel ...

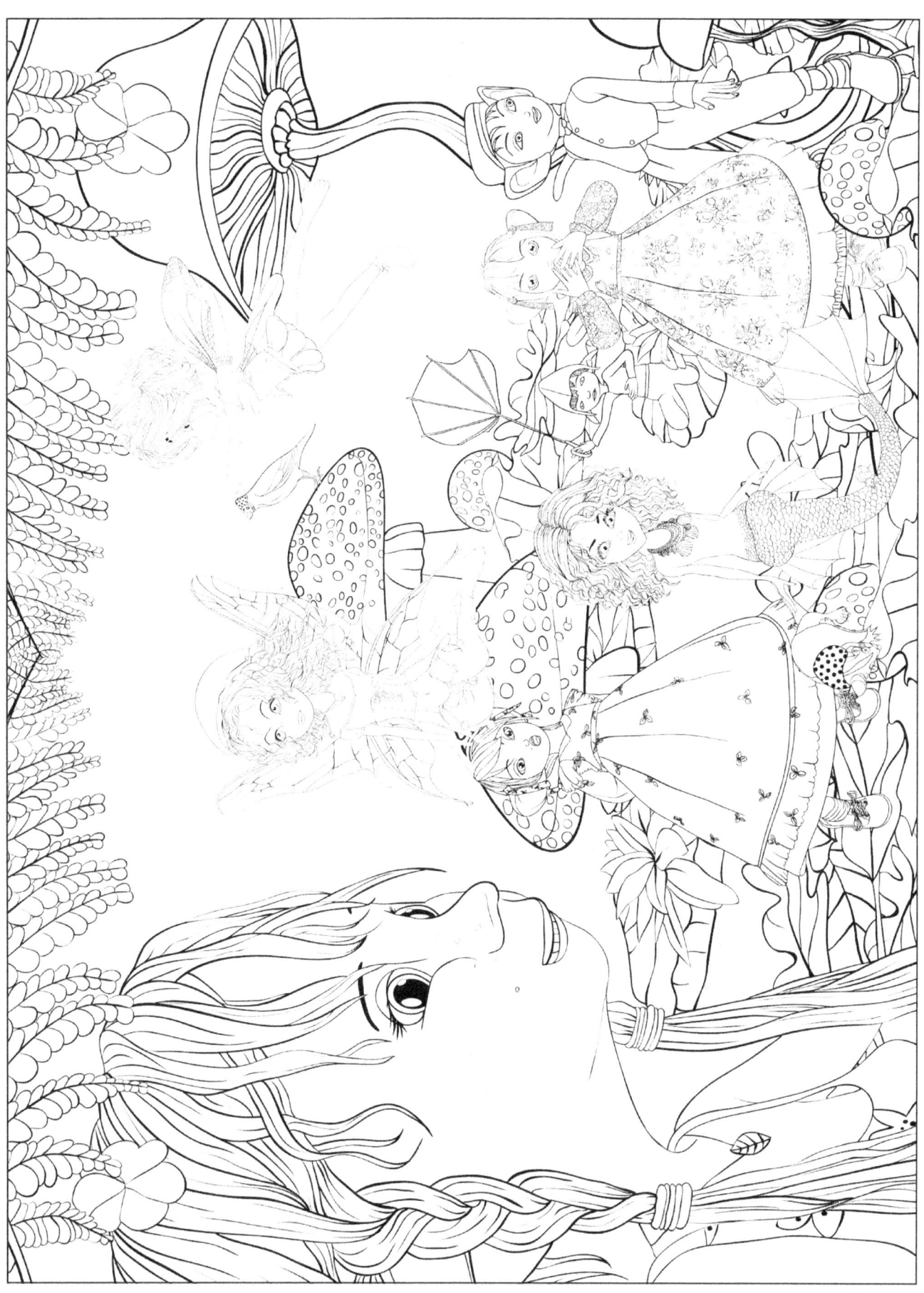

"Rebella's Remorse"

With each passing day, Rebella is regretting her decision to be with the Leaf Goblin. She misses her friends and home at Waterlily Woods. She looks on to her faerie friends from the Woodlands full of remorse and wants to return home but will they have her back?

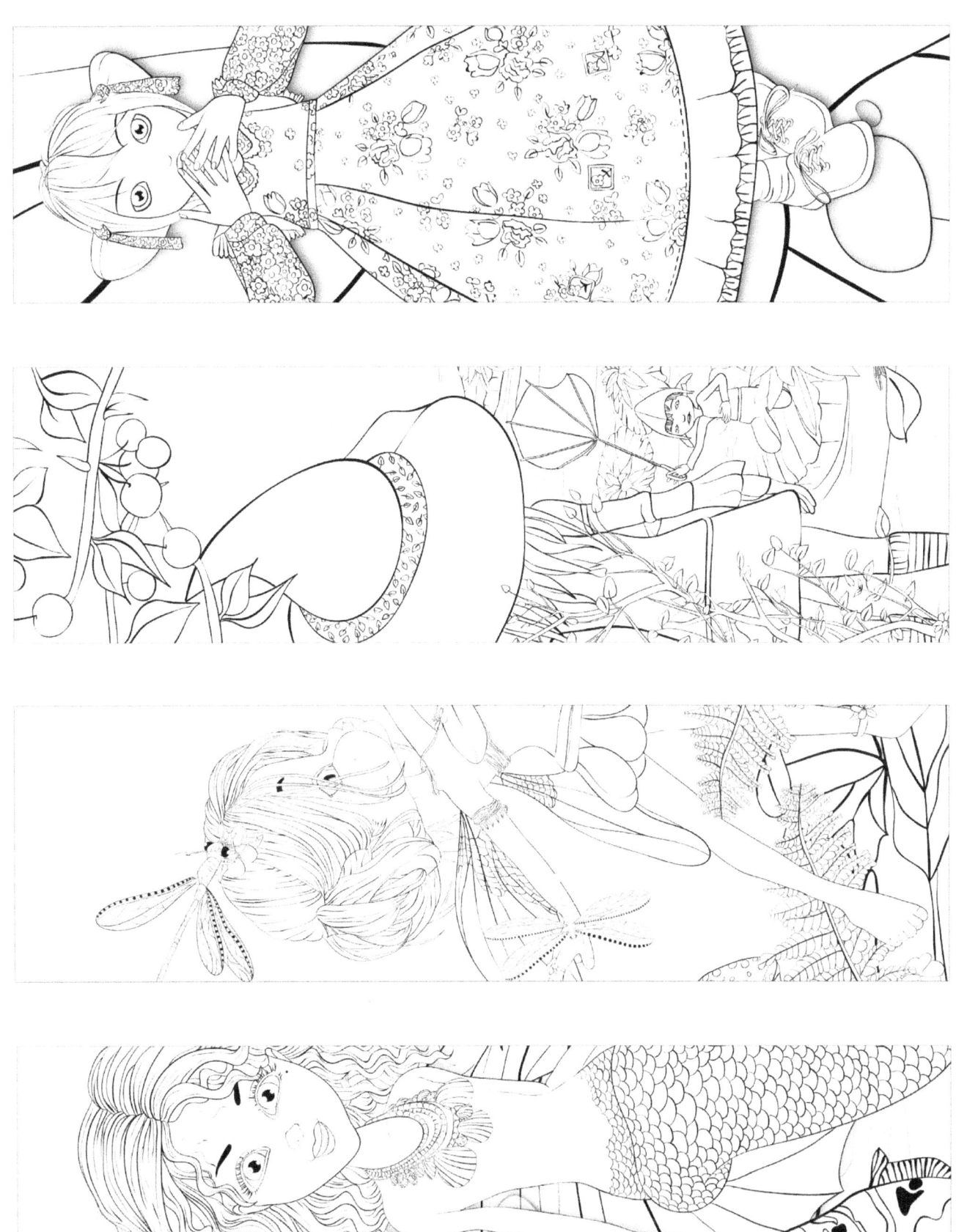

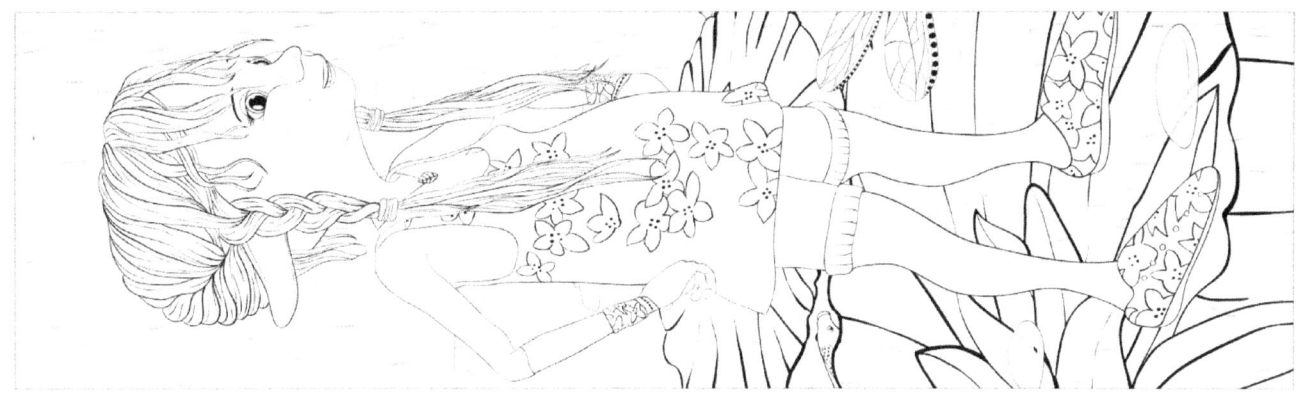
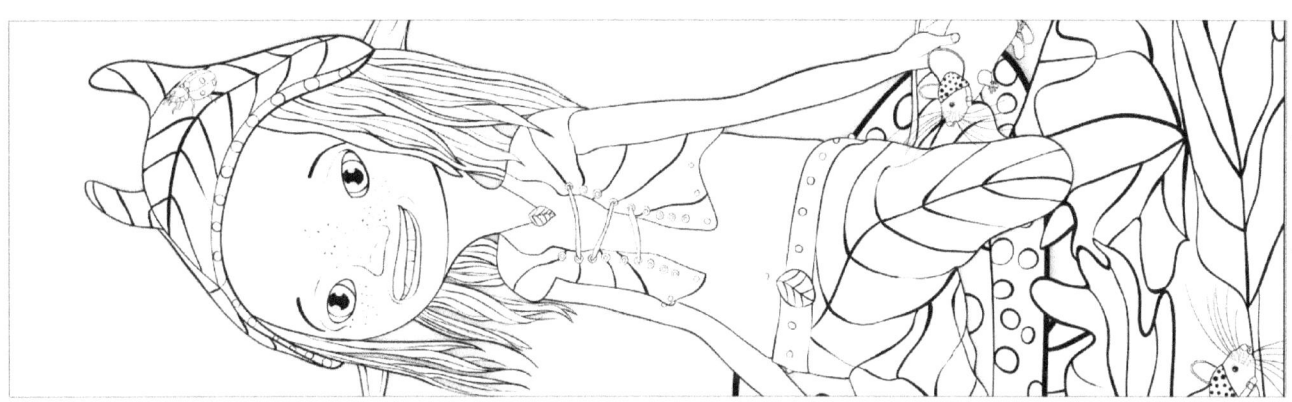
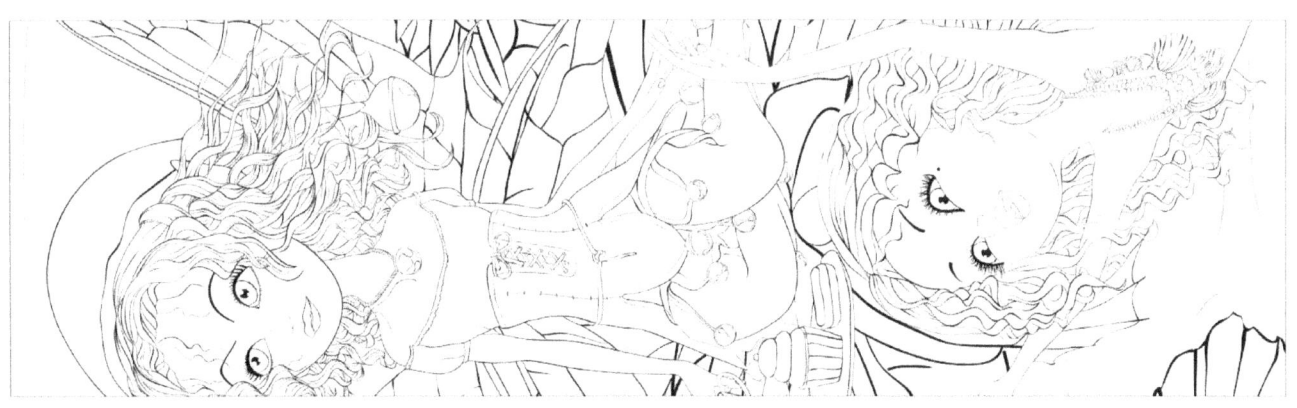
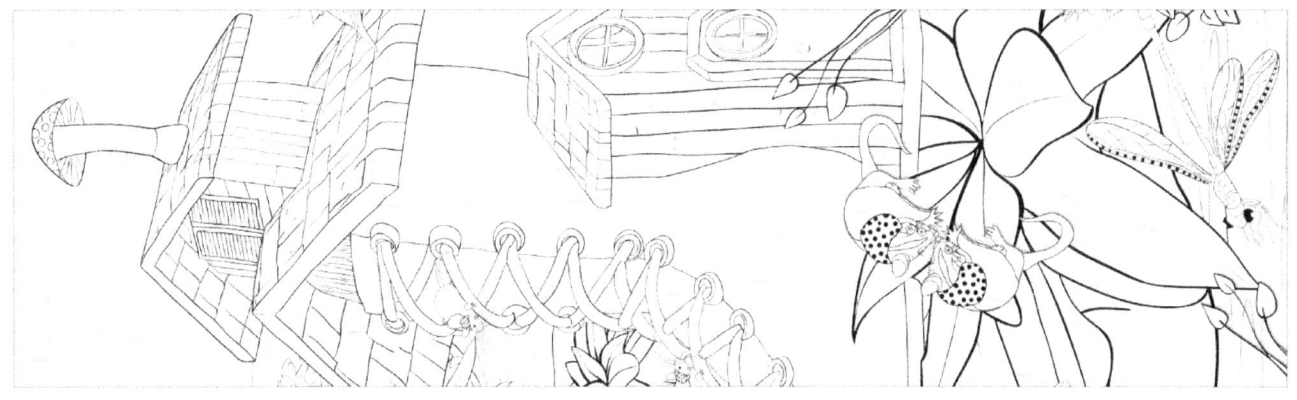

Thank you for choosing this book and bringing the Faeries of Waterlily Woods to life with colour.

I would love to see your colourings and invite you to join the Colouring and Tangling Group on Facebook where you can post your colourings from this book and stay up-to-date with future books and products.

Not on Facebook? Send me your colourings via e-mail for inclusion in the Colouring and Tangling Website Galleries.

It would also mean the world to me if you could leave a review on Amazon about this book if you enjoyed it. If you notify me when you have left a review I will send you a wonderful surprise straight to your e-mail box.

Lesley Smitheringale - lesley@colouringandtangling.com
www.colouringandtangling.com
https://www.facebook.com/groups/colouringandtangling

www.ingramcontent.com/pod-product-compliance
Lightning Source LLC
Chambersburg PA
CBHW080554190526
45169CB00007B/2774